DÜRER

AND THE VIRGIN IN THE GARDEN

Susan Foister

National Gallery Company, London
Distributed by Yale University Press

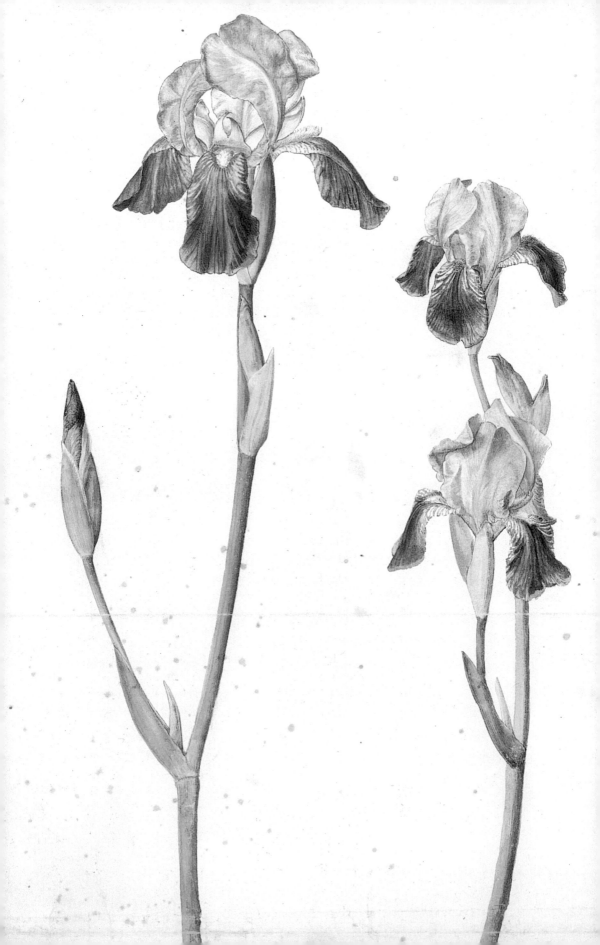

Director's Foreword

The National Gallery's *Virgin and Child ('The Madonna with the Iris')* has been the subject of a series of fascinating changes in reputation. First recorded in Vienna in 1821, it was purchased by the Gallery in 1945 as an autograph work by Albrecht Dürer, one of the greatest artists of the Renaissance. Yet, although the painting had been universally held to be Dürer's work in the pre-war period, hardly more than a decade after it was acquired this attribution was discredited and it was relegated to the status of a copy or pastiche of Dürer's work from around a hundred years after his lifetime. In recent years, however, questions of authorship and the ways in which fifteenth- and sixteenth-century painters worked have been viewed and posed differently, as well as in different contexts. Scholars have taken the painting seriously again, and argued that – although not the work of Dürer himself – it is likely to be a product of Dürer's workshop in the early sixteenth century, as it makes use of a number of his detailed studies of plants, flowers and other motifs. Recently the National Gallery cleaned the painting and undertook a detailed technical investigation, published in the *National Gallery Technical Bulletin: Volume 21*, which supported the contention that the painting was a sixteenth-century work. The remarkable underdrawing, perhaps the work of Dürer himself, was revealed and presented there for the first time.

The National Gallery painting was created using some of Dürer's most beautiful studies. We are immensely grateful to all the lenders to the exhibition: the Albertina and Kunsthistorisches Museum in Vienna, the Kunsthalle Bremen, the J. Paul Getty Museum, Los Angeles, and, in the United Kingdom, Her Majesty The Queen, the British Museum, London, and the Ashmolean Museum, Oxford, for their generous support, which has enabled us to present the genesis of the painting for the first time. We are also enormously indebted to Dr Fritz Koreny, whose reassessment of the painting in 1985 prompted much of our own investigation, for his support and interest in the project throughout.

Charles Saumarez Smith
Director, The National Gallery, London

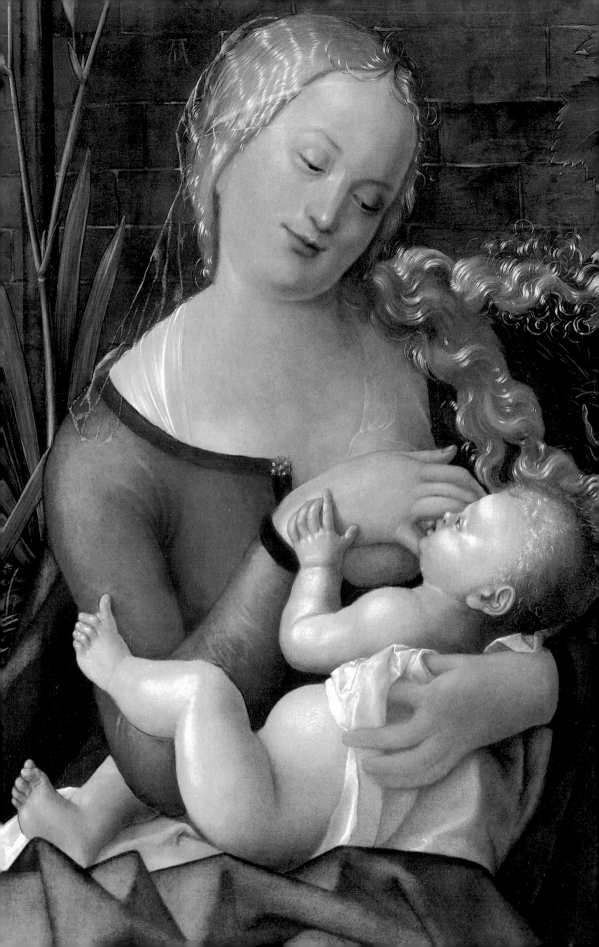

Dürer and the Virgin in the Garden

The Virgin in the Garden is one of the most beautiful subjects in the history of art. Its origins lie in the richly symbolic medieval cult of the Virgin Mary, mother of Christ, in which her life and personal attributes were celebrated with imagery drawn from a garden filled with flowers. The subject was well-established throughout Europe by the time Albrecht Dürer (1471–1528) began work as a painter, printmaker and designer in late fifteenth-century Germany. As landscape depiction and the representation of natural phenomena in painting developed, artists took the opportunity to celebrate not only the Virgin herself, but also, and increasingly, the natural world and the beauty of the spring landscape. Few did this as well as Dürer, with his atmospheric landscapes and exquisite portrayals of individual plants, studied directly from nature.

Medieval devotional imagery in praise of the Virgin was drawn from Biblical language. The Old Testament Song of Solomon is a love poem in which a woman is compared to 'the rose of Sharon, and the lily-of-the-valleys' (2: 1) and to an enclosed garden which, when applied to the Virgin, was interpreted as a symbol of her perpetual virginity. In pictorial representations of the Virgin in a garden, the imagery of the Garden of Eden – from which Adam and Eve were banished after they had succumbed to temptation – is recalled frequently, for the Virgin was celebrated as a second Eve: the birth of Christ saved mankind from the consequences of our Fall from grace. Salvation or eternal life was often presented in the form of the paradise garden, and so images of the Virgin in the Garden encapsulated the central message of medieval Christianity.

Such theological considerations might appear complex and cerebral, but their translation into imagery in tapestries, manuscript illumination and paintings offered the opportunity for copious visual delights, including the use of specific and varied horticultural imagery. Many of the flowers particularly associated with the Virgin are those found in the lushness of May and June, late springtime and early summer, when irises, roses, peonies, lilies, lily-of-the-valley (in German 'Maiglockchen' or little May bells), columbine, cornflowers and violets are in bloom. These are the flowers represented in images of the Virgin's garden: they are not imagined, but can almost invariably be identified as among the 300 or so plants grown in Northern Europe in around 1500, many of them for

Detail of fig. 22

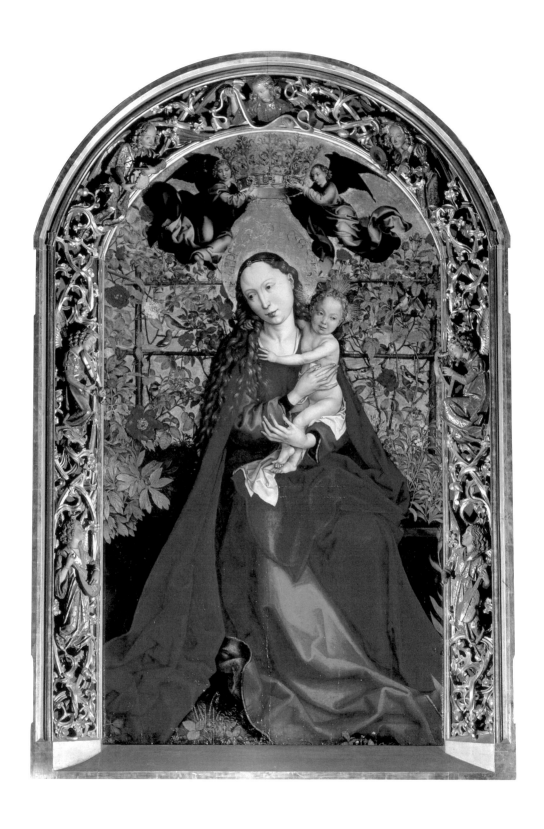

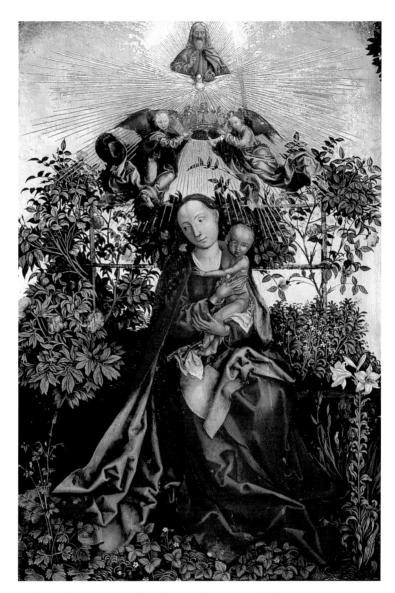

medicinal reasons as well as for their beauty. Similarly, the grassy benches, pot-trained plants and arbours covered in vines or roses shown in paintings of the time reflect the formal and highly cultivated style of medieval gardens.

Members of late-medieval society would have said their prayers in front of paintings of the Virgin; large altarpieces showing scenes from her life stood in churches and small images were used for private devotion in the home. One of the greatest German images of the Virgin in the Garden, and one which had great significance for Dürer himself, is the altarpiece by the famous painter and engraver Martin Schongauer

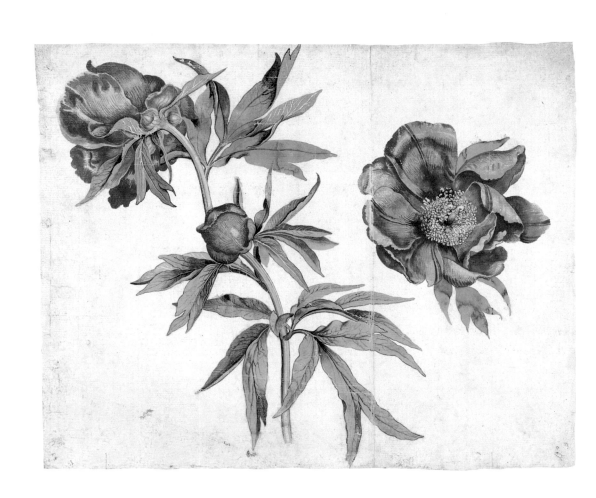

(active 1469; died 1491), painted in 1473 for the church of St Martin in Colmar, Alsace, present-day France (fig. 1). The Virgin sits in front of a rose-covered trellis and is crowned by angels. In a copy in Boston, which shows the composition of the painting before it was cut down, there are peonies to the left and a lily to the right, as well as God the Father looking down from heaven (fig. 2). Peonies were known in Germany as 'Pfingstrosen', the roses of Whitsuntide. Similar in appearance to roses, but without thorns, they were appropriately symbolic of the Virgin.

Although we do not know when he acquired it, Dürer almost certainly owned the exquisite coloured study of peonies by Schongauer (fig. 3) which, along a cut edge, bears traces of handwriting similar to Dürer's. Schongauer had used his peony study to create the peony bush originally on the left of his altarpiece in the church of St Martin (figs 1 and 2). In 1492 the young Dürer had visited Colmar, wanting to make contact with Schongauer, but he was too late: Schongauer had only recently died. None the less Dürer would have seen the great altarpiece of the Virgin, and must also have returned from Colmar with some material from Schongauer's workshop, perhaps a sheaf of engravings, certainly at least some drawings which today bear inscriptions by him.

A small painting in the National Gallery, probably produced in Schongauer's workshop in the late fifteenth century, is one of many such images that would have been used for private devotion (fig. 4). The painting shows the Virgin seated on a grass-topped wooden bench from which flowers grow. Seats or benches in the form of raised turf-covered banks, often including a number of small plants, are first mentioned in 1260 by the scholar Albertus Magnus (about 1208–1280) and were made by placing turf over a timber-framed box filled with rubble. Behind the Virgin and Child, within the boundary established by a wattle fence, is a cherry tree, associated with the Virgin in contemporary devotional imagery such as the medieval English 'cherry tree carol'. In this carol the pregnant Virgin walks with Joseph in an orchard 'Where was cherries and berries, so red as any blood'. One of the cherry trees bows down to allow her to eat its fruit, the colour of which symbolises the sacrifice her unborn son will make on the cross.

There are many other plants in the painting. In the lower left-hand corner in front of the Virgin's cloak is a strawberry plant, shown with both white flowers and red fruit: sweet and stoneless, the strawberry was also associated with the Virgin. Near the grassy bench on the left are lily-of-the-valley, with white bell-shaped flowers. Behind them are violets, again the Virgin's flower, as well as red campion and white stock. Some flowers had specific symbolic messages. The Virgin holds a pink carnation towards the naked Christ Child, who appears to draw back from it: the pink, or carnation, known in Germany as the 'Nelke' or nail flower, was associated with the sacrifice Christ made when he was nailed

3
Martin Schongauer (active 1469; died 1491)
Study of Peonies, about 1472–3
Watercolour and gouche on paper
25.7 × 33 cm
The J. Paul Getty Museum, Los Angeles

9

to the cross. In the lower right-hand corner is a clump of blue irises (in German, 'Schwertlilie') or sword lily, a name suggested by the shape of its leaves, and related to the piercing sorrow felt by the Virgin at the death of her son. Though small in scale, the irises and other plants are depicted with a fleshy presence, which makes the garden vivid.

'The more exactly one equals nature,' Dürer wrote, 'the better the picture looks.' As well as collecting studies by others, Dürer himself made numerous studies of natural phenomena throughout his career, intended for use in both paintings and prints. His earliest nature studies included a number of landscapes depicting ponds and quarries made around his native city of Nuremberg, as well as some representations of landscapes with buildings – he made others when he crossed the Alps in the mid 1490s. Unlike his contemporary Albrecht Altdorfer (shortly before 1480–1538), Dürer never produced finished paintings in which landscape was the sole subject, but his studies show his interest in atmosphere and space, as well as topographical details. He used his drawings and watercolours of plants, animals and landscape scenery to create animated and atmospheric backgrounds to both religious and secular subjects.

The tiny painting of *Saint Jerome* in the National Gallery (fig. 5) appears to date from 1496, shortly after Dürer's return to Nuremberg from Italy. The elderly saint kneels in prayer before a crucifix projecting from a tree stump. In his left hand he holds a stone with which to beat his breast in penitence. Behind him is an extraordinarily beautiful scene, with trees, distant mountains and a sky streaked with the pink and lemon of sunset or sunrise. The atmospheric nature of this setting appears to owe much to one of Dürer's most evocative watercolour studies, the *Landscape with a Woodland Pool* (fig. 6). Although in legend Jerome lived in the Syrian desert, Dürer has used the studies he made around Nuremberg to create a Northern-European equivalent. Jerome's monastery appears in the distance on the left, with a snow-capped Gothic steeple and bell tower. On the right the craggy rocks crowned by trees must have been inspired by Dürer's studies of the local landscape, although his studies of quarries have been turned into towering mountains. The scene also includes animals, again presumably based on Dürer's own studies. In the lower right-hand corner are two birds beside a tumbling stream; one is a goldfinch, often symbolic of Christ's Passion. On the right is the lion which, according to legend, approached Jerome with a thorn painfully embedded in its paw. The saint removed it and the lion became his faithful companion.

One of the studies that Dürer must have used to create this scene survives: the coloured drawing of a lion now in Hamburg. Not all 'nature studies' were made directly from nature. The lion study used for Dürer's painting of Saint Jerome was in all probability not based on a real animal

4
Style of Martin Schongauer
The Virgin and Child in a Garden, 1469–91
Oil on lime
30.2 × 21.9 cm
The National Gallery, London

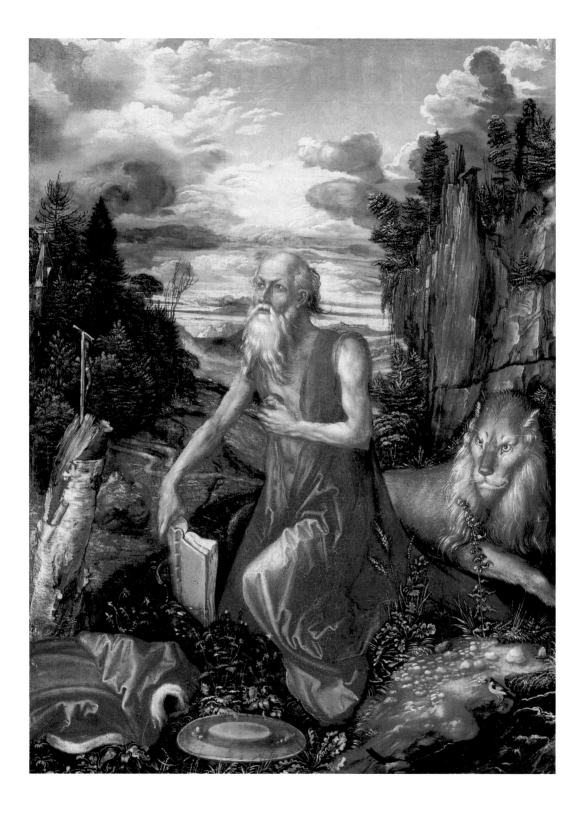

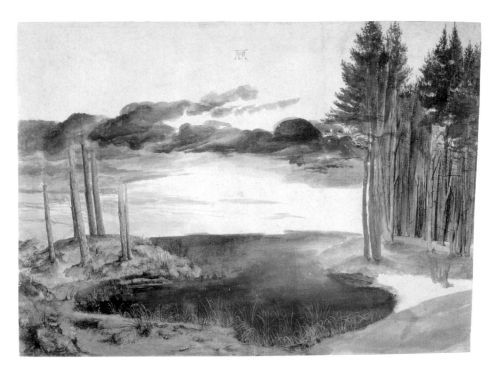

5 (opposite)
Saint Jerome,
about 1496
Oil on pearwood
23.1 × 17.4 cm
The National
Gallery, London

6
**Landscape with a
Woodland Pool**,
about 1496
Watercolour and
bodycolour on
paper
26.2 × 36.5 cm
The British
Museum, London

but adapted from paintings, drawings or engravings made by others. Artists were expected to be as skilled at animating such unnatural phenomena as copying after nature itself. Model books, kept in the workshop for use in all the artist's commissions, enabled a work by one artist to be transmuted into the style of another and made to seem real. At least one very early landscape work by Dürer appears to be based on a study, the *Landscape with Wanderer* in Erlangen, by another Nuremberg artist. Similarly, Dürer's magnificent coloured study of an elk (British Museum, London) may not have been made after a living animal.

In Schongauer's peony study (fig. 3) however, the exact observation of botanical details, such as the variegated striations on the sepals and stem, suggests careful examination of the plant. Dürer seems to have followed Schongauer's example in making similar botanical studies from life. The beautiful study of an iris (*Iris germanica*) on two sheets of paper to represent its length is a rare example (fig. 7). Like the sheet with studies of the *Lily-of-the-Valley and Bugle* (fig. 8), which appears to have been executed by an assistant working with Dürer, this careful study of *Irises* recalls botanical drawings or woodcuts in medieval herbals in its clarity and positioning on a completely plain background.

The *Great Piece of Turf* (fig. 9) is strikingly different. Not only does it resemble a miniature landscape at eye-level to an ant, it also consists entirely of different aspects of common foliage, weeds and grass. There are no flowers, merely a few dandelions in bud. The absence of bright

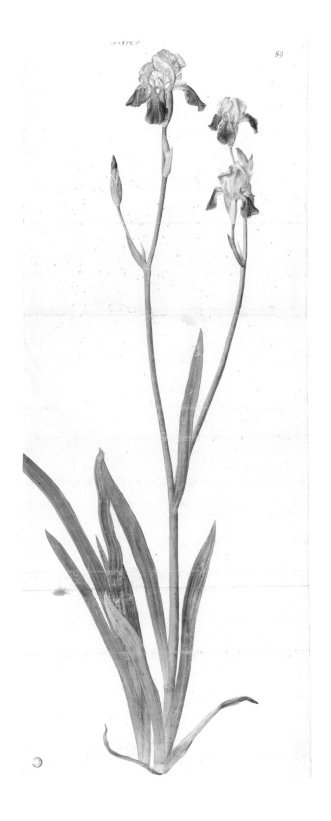

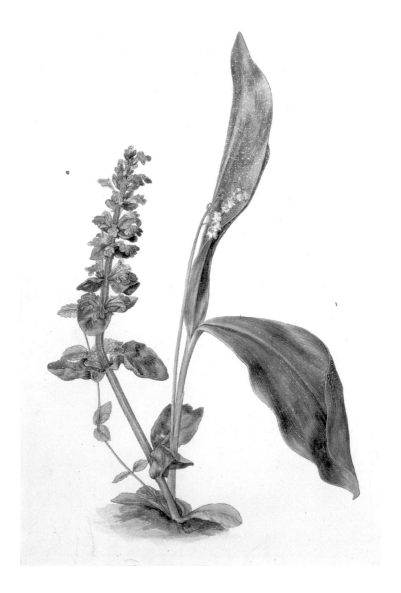

7 (opposite)
Irises, probably
about 1503
Watercolour on
paper
77.5 × 31.3 cm
Kunsthalle Bremen,
Kupferstichkabinett

8
Attributed to the
workshop of Dürer
**Lily-of-the-Valley
and Bugle**, early
1500s?
Watercolour and
bodycolour on
paper
25.7 × 17.5 cm
The British
Museum, London

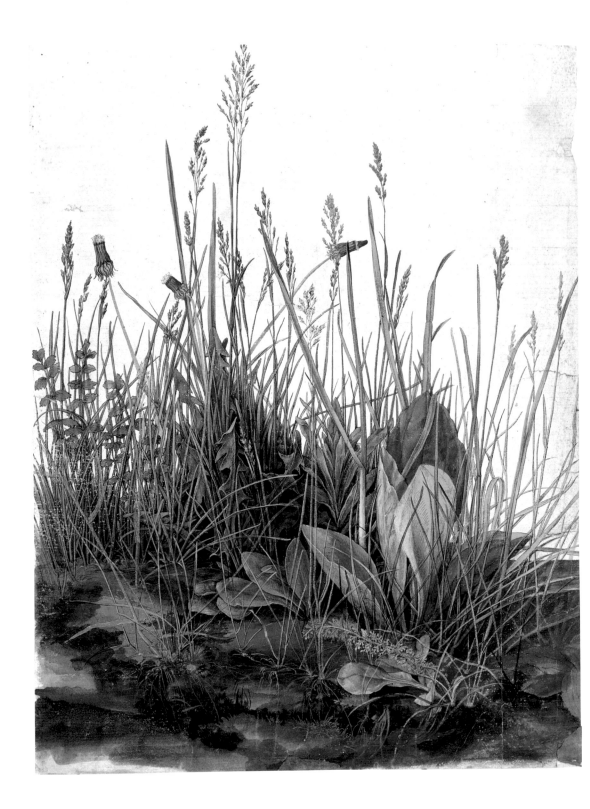

colour or a sense of composition makes it appear as an unedited piece of reality, but the elements must have been carefully chosen and composed, perhaps even consisting of a number of individual studies put together. However, the plants are exactly those typically found in a meadow in southern Germany in May. It has been suggested that Dürer's study was made with knowledge of the Neoplatonic writer Marsilio Ficino's (1433–1499) discussion of the classical painter Apelles' reproduction of individual blades of grass from an image held in his mind, or that the study was intended to epitomise the divine creation of nature. Given the Nuremberg intellectual circles in which Dürer moved, this is certainly possible. Yet many fifteenth-century Northern paintings of religious subjects include great expanses of grass and plants such as plantain and dandelion in their foregrounds – although those emphasising weeds rather than flowers often occur in paintings of Christ's suffering and crucifixion, in contrast to the flowers in images of his mother and of his childhood. Even woodcuts by Dürer include tufts of grass and mixed plants; take, for example the foreground of the *Holy Family with Three Hares* (fig. 10). Since depictions of the Virgin and Child in a garden – a subject associated with Maytime – were not always executed while the spring flowers were in bloom, it was important to have such studies available in the workshop.

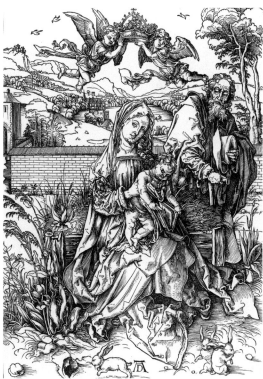

9 (opposite)
The Great Piece of Turf, 1503
Watercolour and bodycolour on vellum
40.3 × 31.1 cm
Albertina, Vienna

10
Holy Family with Three Hares,
about 1497–8
Woodcut
38.2 × 27.8 cm
The British Museum, London

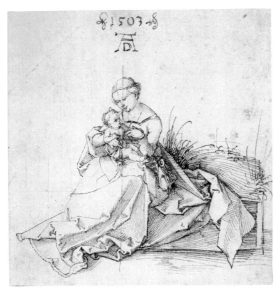 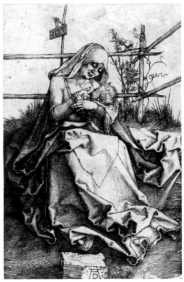

Images of the Virgin were greatly in demand when Dürer began his career, and it is hardly surprising that he produced so many of them – for prints as well as paintings – both large and small. Dürer's earliest surviving representations of the Virgin are explorations of the Virgin and Child theme, small sketches made with ink on paper, experiments in showing the play of light on folds of drapery, as well as in depicting the relationship between mother and son (figs 11–15). Dürer's constant exploration of variations is comparable to the sketches being made by Italian artists such as Leonardo da Vinci and Raphael at about the same time. They are indicative of a creative drive and imagination in Dürer's work that took him beyond the imitation of the pattern book to transform old subject matter. This exploration is reflected further in the way in which Dürer's style evolved constantly during his career. In drawings such as these the depiction of drapery, for example, changes, from the very detailed hatching and pointed folds used by Schongauer (fig. 13), to more widely spaced and simplified shading (figs 14–15) At the same time Dürer's compositions gradually became simpler and more monumental.

Dürer developed the relationship between the mother and the Child – the Child looking away or towards his mother, the differing relationships between bent heads, or the way the Virgin holds the Child – in a number of beautiful small studies. The drawing of the *Virgin and Child on a Bank* (fig. 11) is outstanding among this series, which culminates in an engraving made in 1503 (fig. 12), a composition of exquisite clarity in which the figures are set against the geometric trellis of a vine. Such studies must also have informed the extremely tender 1503 painting of the *Virgin and Child* now in Vienna (fig. 16). The Child is seen only from the back, his

11 (above left)
Virgin and Child on a Bank, 1503
Pen and ink on paper
17.6 × 17.5 cm
The British Museum, London

12 (above right)
Virgin and Child on a Bank, 1503
Engraving
11.8 × 7.5 cm
Ashmolean Museum, Oxford
Douce Bequest, 1834

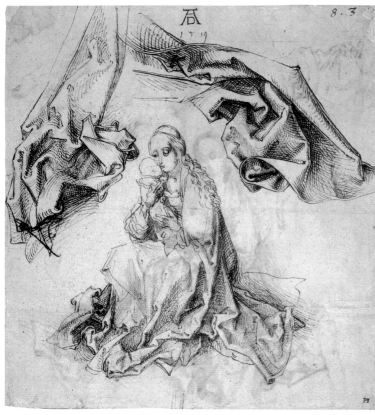

13
Seated Virgin and Child, about 1490–4
Pen and brown ink on paper
20.5 × 19.7 cm
The British Museum, London

14 (below left)
Virgin and Child, 1515
Pen and ink on paper
27.6 × 20.5 cm
The Royal Collection

15 (below right)
Virgin and Child, 1514
Pen and brownish ink on paper
28 × 19.6 cm
Ashmolean Museum, Oxford
Chambers Hall Gift, 1855

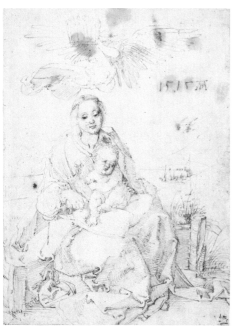

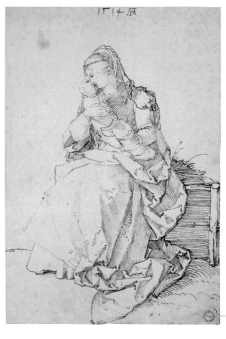

head resting against the Virgin, whose joyful face the viewer sees. In this way the helplessness and humanity of Christ as an infant, dependent on his mother for nourishment and care, is emphasised; the central doctrine of the Incarnation, Christ made man in order to save mankind, is underlined.

Dürer also painted large altarpieces celebrating the Virgin, notably the great *Feast of the Rosegarlands*, dated 1506 (National Gallery, Prague), for the German merchants of Venice, and, after his return to Nuremberg (by February 1507) the Heller Altarpiece of the *Assumption of the Virgin* (now lost). The *Assumption* cost him a good deal of trouble and it seems to have deterred the artist from undertaking other extensive commissions himself, although he continued to supply compositional ideas for large paintings produced by the workshop. Indeed, the artist wrote to Heller on 26 August 1509, complaining that 'No one could ever pay me to paint a picture again with so much labour … Therefore I shall stick to my engraving'. His subsequent woodcut series of the *Life of the Virgin* was published in 1511, and was preceded by a number of prints, including the engravings of the *Virgin and Child with a Dragonfly* (fig. 17) and the *Virgin and Child with a Monkey* (the monkey, a symbol of lewdness, greed and gluttony, was associated with Eve, fig. 18), the woodcut *Holy Family with Three Hares* (fig. 10), and the small engraving of 1503 (fig. 12). All of these present variations on the theme of the Virgin and Child on a grassy bench in a garden.

One of the most beautiful of all Dürer's images of the Virgin is the

16 (opposite)
Virgin and Child,
1503
Oil on panel
24 × 18 cm
Kunsthistorisches
Museum, Vienna

17 (below left)
**Virgin and Child
with a Dragonfly**,
about 1495
Engraving
23.6 × 18.5 cm
The British
Museum, London

18 (below right)
**Virgin and Child
with a Monkey**,
about 1498
Engraving
19.1 × 12.3 cm
The British
Museum, London

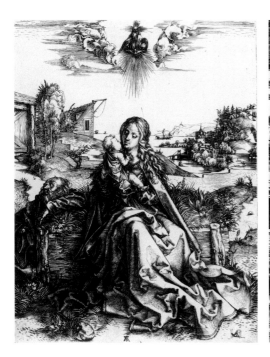

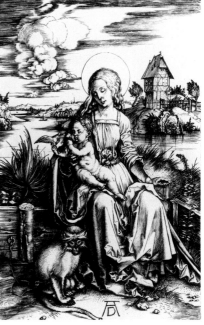

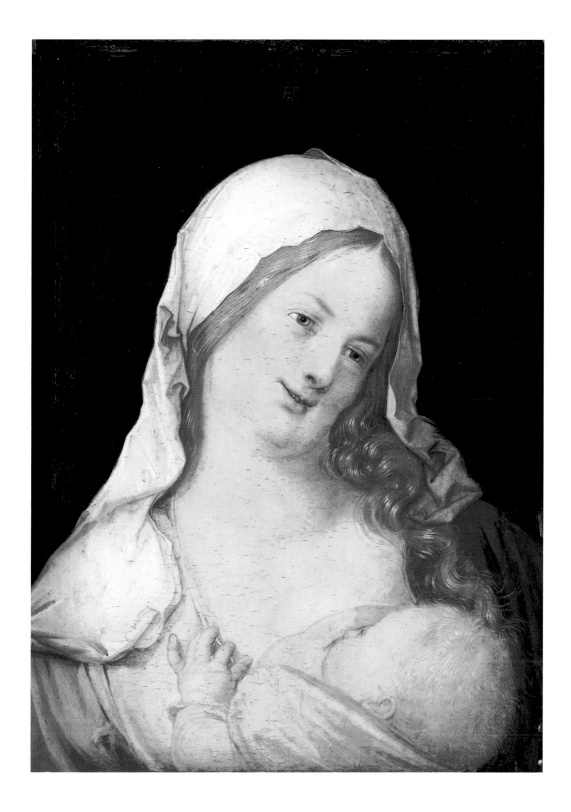

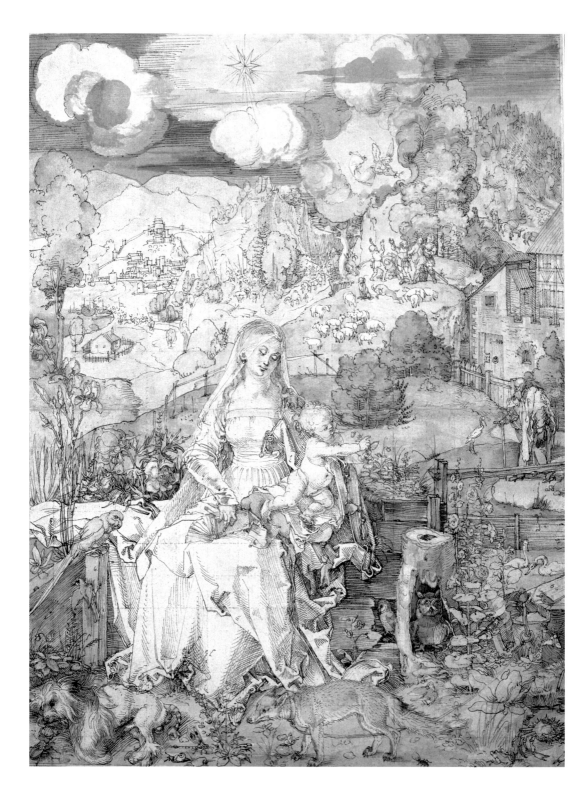

19 (opposite)
The Virgin with the Animals, about 1503
Pen and ink and watercolour on paper
31.9 × 24.1 cm
Albertina, Vienna

20 (above right)
Jan Provoost (living 1491; died 1529)
The Virgin and Child in a Landscape, early sixteenth century
Oil on wood
60.2 × 49.5 cm
The National Gallery, London

21 (below right)
Virgin and Child with Animals, 1503
Pen and watercolour on paper
32 × 23.8 cm
Musée du Louvre, Paris

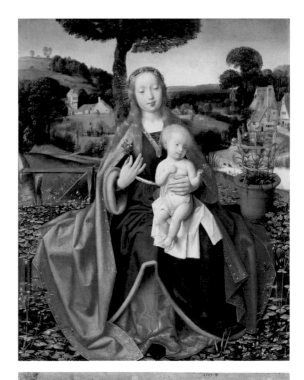

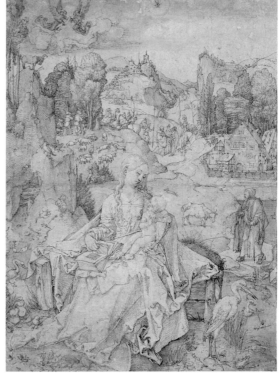

highly-finished, detailed watercolour study of the *Virgin with the Animals* (fig. 19). It shows the Virgin and Child sitting on a grassy bench with peonies and irises growing nearby and, in the distance, an extensive landscape in which Joseph can be seen. On the right is the Annunciation to joyful shepherds, while to the left the Magi process to give their devotion to the newborn Saviour. The child is reaching out towards a flower, and on the ground are strawberries. The detail of the background is comparable to Netherlandish paintings of the period such as one by Jan Provoost (fig. 20), a painter from the Low Countries working in the early sixteenth century. In this painting a broad landscape including a small village unfolds behind the Virgin. The garden itself is evoked merely by the grassy bench on which she sits, and the terracotta pot of carnations on her right, which grow supported by a carefully made wooden frame with carved finials. In Dürer's study animals as well as flowers are prominent: a fox, a dog, a stork, a crab, owls and a parrot, a snail and a tiny but accurately realised stag beetle are included. The composition is a celebration of the life of the Virgin and the power of the Christ Child; the parrot was thought to herald the Virgin, while the fox and the owls are symbols of the evil her Child will overcome. The infant Christ is lord of creation in this ideal landscape – the extended garden a metaphor for paradise.

This watercolour, which was executed with extreme care, probably dates from about 1503, when Dürer was working on his series of woodcuts of the *Life of the Virgin*. There is a study for it in Berlin, and there are traces of squaring, probably not by Dürer himself, perhaps indicating that it was to be used again. Dürer also made another version of it, dated 1503 now in the Louvre (fig. 21). This suggests that he was thinking of the *Virgin with the Animals* as a study he could use either for a print, or, conceivably, for a large painted composition. The Louvre drawing shows changes in the way the Virgin's head turns round to bend over the child, and also to the drapery, which resemble aspects of a large painting in the National Gallery (fig. 22). This is not by Dürer himself, but has been convincingly attributed to his workshop.

In this painting the fair-haired Virgin has apparently just finished feeding the child on her lap, for the jewelled fastening at the top of her dress has been undone. Behind the grassy bank on which she sits is a stone wall with a partly ruined arch, through which the sea can be glimpsed. Above the Virgin's head in the sky is the small figure of God the Father. Immediately behind her is a trellis supporting a vine, while flowers surround her: on the left an iris, on the far right a deep pink peony, a lily-of-the-valley (in leaf only) and a bugle. The peony, lily-of-the-valley and iris are, as we have seen, traditionally associated with the celebration of the Virgin. The vine symbolises Christ's future sacrifice.

This large painting appears to have been developed from Dürer's explorations of the Virgin and Child theme of around 1503. The

22
Workshop of Dürer
The Virgin and Child ('The Madonna with the Iris'),
about 1500–10
Oil on lime
149.2 × 117.2 cm
The National Gallery, London

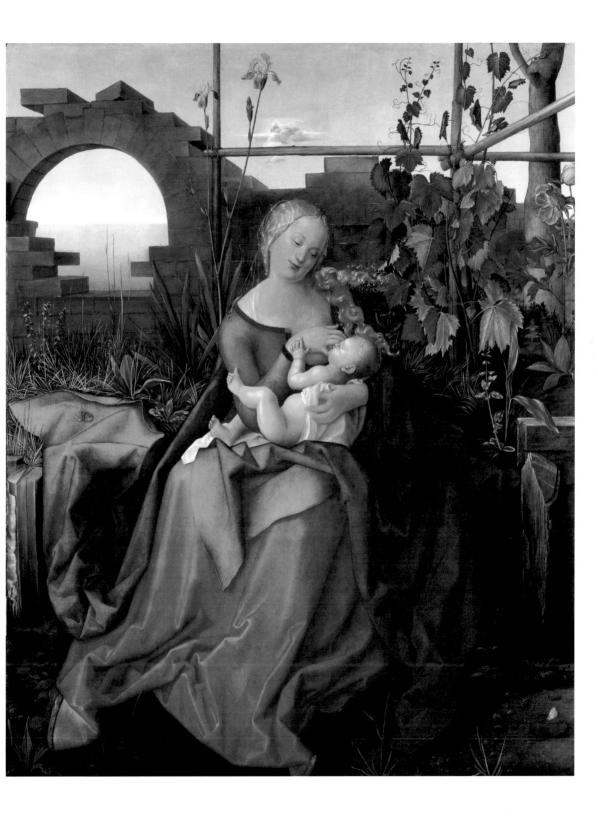

composition has many similarities with other works by the artist, particularly the small 1503 engraving (fig. 12) and the *Virgin and Child* in Vienna (fig. 16). Most strikingly, the plants are based on some of Dürer's most famous studies. The iris is similar to the study now at Bremen (fig. 7), the peonies to the Schongauer study owned by Dürer (fig. 3). The foliage on the left of the grassy bench is taken from the *Great Piece of Turf* (fig. 9), while the lily-of-the-valley and bugle follow the study in the British Museum (fig. 8). Although this drawing and the plants in the painting do not at first sight seem very similar, when a tracing of the painted plants is placed over the drawing and then seen at different angles, it becomes clear that various parts of the two are virtually identical. The plants in the painting must therefore have been created from a pattern adapted directly from the drawing. The painting of the iris is slightly different to the study in Bremen, but a number of changes were made to its preparatory underdrawing, visible today with the aid of infrared reflectography.

One of the most interesting indications that the painting is associated with Dürer and his workshop is found in the underdrawing (figs 24 and 26). This shows the densely hatched drapery and the use of conventions such as fishbone-style folds found in the work of German painters of the late fifteenth and early sixteenth century, for example the Master of the Saint Bartholomew Altarpiece (active about 1470–1510). A similar, albeit less detailed, style has been detected in works by Dürer that have been investigated with infrared reflectography, especially earlier pieces such as the Paumgartner Altar in the Alte Pinakothek, Munich. The parallel between a number of drawn drapery studies by Dürer (see fig. 13) and the underdrawing of the painting (fig. 26) is particularly striking. However, there is also a clear difference between the very detailed underdrawing for the central figure, with its numerous small adjustments, and the approach to the background, where much less underdrawing is visible. The iris, for example, has been much more freely underdrawn and then its position altered – raised for the final painting (figs 23–4). Such a disparity might be explained by the use of different types of workshop model for the central figure and for the background, as well as by the involvement of more than one painter in the production of the picture.

Who would have produced such a painting, following Dürer's drawings so closely? In order to fulfil the demand for commissions Dürer had, in accordance with common practice, established a workshop that included the painters Hans Suess von Kulmbach, Hans Schauffelein and Hans Baldung Grien. Dürer used his own nature studies to create prints and paintings, and his assistants would have made use of these too, as well as the many other drawings and prints Dürer accumulated. It has been plausibly suggested that Dürer's workshop assistants undertook painting while he was away in Venice in 1505–7.

One of the most interesting indications that the painting is associated with Dürer and his workshop is found in the underdrawing (figs 24 and 26). This shows the densely hatched drapery and the use of conventions such as fishbone-style folds found in the work of German painters of the late fifteenth and early sixteenth century, for example the Master of the Saint Bartholomew Altarpiece (active about 1470–1510). A similar, albeit less detailed, style has been detected in works by Dürer that have been investigated with infrared reflectography, especially earlier pieces such as the Paumgartner Altar in the Alte Pinakothek, Munich. The parallel between a number of drawn drapery studies by Dürer (see fig. 13) and the underdrawing of the painting (fig. 26) is particularly striking. However, there is also a clear difference between the very detailed underdrawing for the central figure, with its numerous small adjustments, and the approach to the background, where much less underdrawing is visible. The iris, for example, has been much more freely underdrawn and then its position altered – raised for the final painting (figs 23–4). Such a disparity might be explained by the use of different types of workshop model for the central figure and for the background, as well as by the involvement of more than one painter in the production of the picture.

23 (opposite, left)
Detail of fig. 22

24 (opposite, right)
infrared reflecto-gram mosaic detail of fig. 23

25 (opposite, left)
Detail of fig. 22

26 (opposite, right)
infrared reflecto-gram mosaic detail of fig. 25

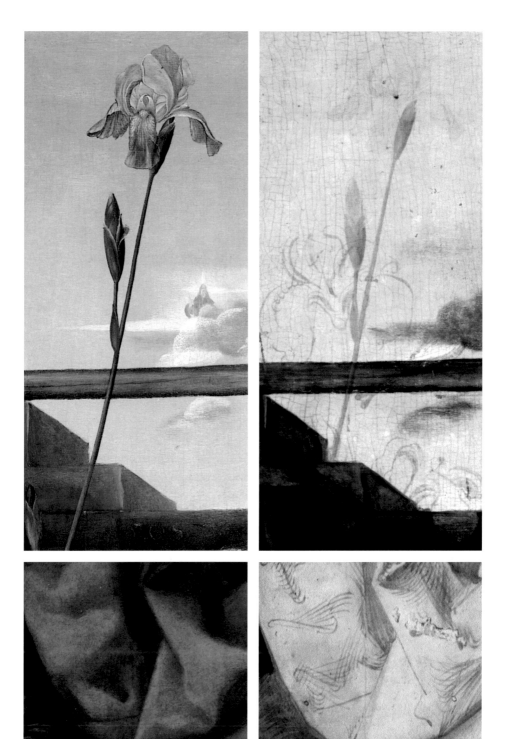

Close study of the painting has shown that it underwent several stages during which details, particularly in the background, were changed. The underdrawing established the position of the Virgin and the basic shape that she and her flowing draperies make. There is a certain degree of confidence in the overall placement of the figures that suggests that they were drawn with reference to existing drawings. Numerous small changes, however, were then made to the underdrawing. In the background drawing is limited to the main features, but the composition was established with a number of carefully made reserves (spaces in the paint layer) for plants, which were drawn but obliterated when a second layer of paint was applied to the wall. New plants and foliage to the left and right were then added, as was the figure of God the Father in the sky. The broad application of this second layer contrasts with the neatly painted reserves made in the first stage of painting, and the number of changes made between the two paint stages, as well the more careless application of paint on the wall, suggests the intervention of another hand. In addition, the Virgin's veil, the butterflies and the date 1508 were added after varnish had been applied – which, according to common practice would have been some time (perhaps up to three years) after the painting was initially 'completed'. The fact that these details of the butterfly and the veil are present in two early copies of the painting (in Prague and Wilhering, Austria), implies they were part of the early making of the painting, rather than alterations made much later. Despite the intensive analysis the painting has undergone – and the fact that the work seems to have clear ties to Dürer's workshop – it has not been possible to relate any of the execution of the surface paint to the style of specific individuals identified as working with Dürer.

Throughout his life Dürer applied his extraordinary imagination and artistic skill to the representation of subjects drawn from nature, and to their use in his paintings, prints and drawings. His images of the Virgin and Child in landscape settings were founded on traditional subject matter, expressed with great beauty and elegance in the images of the artist Dürer most admired at the start of his career, Martin Schongauer. Reworking these images in different media, from small prints and drawings to large altarpieces, Dürer added to them his own explorations of landscape, plant and animal life, as well as the human form. His studies on paper demonstrate his exquisite draughtsmanship, but in their variety and ambition they are also indicative of Dürer's determination to transform and innovate – to see each subject and motif anew and to make it uniquely distinguishable as his own. Although the National Gallery's picture of the *Virgin and Child* was not painted by Dürer himself, its composition is, at almost every point, informed by the artist's exceptional creativity and ability to define new images – for which Dürer is still rightly celebrated today.

Further Reading

P. Ackroyd, S. Foister, M. Spring, R. White and R. Billinge, 'A Virgin and Child from the Workshop of Albrecht Dürer?' in *National Gallery Technical Bulletin: Volume 21*, London 2000, pp. 28–42

G. Bartrum et al., *Albrecht Dürer and his Legacy*, London 2002

L. Behling, *Die pflanze in der mittelalterlichen Tafelmalerei*, Weimar 1957, pp. 27–9

J. Campbell Hutchison, *Albrecht Dürer*, Princeton 1992

C. Eisler, *Dürer's Animals*, Washington 1991

R. Falkenburg, *The fruit of devotion: mysticism and the imagery of love in Flemish paintings of the Virgin and Child 1450–1550*, trans. S. Herman, Amsterdam and Philadelphia 1994

C. Fisher, *National Gallery Pocket Guide: Flowers and Fruit*, London 1998

F. Koreny, *Albrecht Dürer und die Tier und Pflanzenstudien der Renaissance*, Munich 1985

S. Landsberg, *The Medieval Garden*, London 1996

Chronology

21 May 1471

Born in Nuremberg, one of Europe's most prosperous trading centres, son of the goldsmith Albrecht Dürer the Elder (1427–1502).

30 November 1486

After an initial apprenticeship with his father, becomes apprenticed to the Nuremberg painter Michael Wolgemut.

1490

Leaves Nuremberg, having completed his apprenticeship, in order to undertake the traditional period of professional travel, the 'Wanderjahre'.

1492

Arrives in Colmar to meet Martin Schongauer, but finds that the famous engraver and painter died in 1491. From Colmar travels to Basel and stays in the house of one of Schongauer's brothers, Georg. First surviving signed and dated work, a woodcut of Saint Jerome, is published at Basel in *Epistolare beati Hieronymi*.

1493–4

Active in Strasbourg, where he produces his earliest painted self portrait (now in the Louvre, Paris).

7 July 1494

Marries Agnes Frey in Nuremberg. The marriage remains childless. In the autumn of the year Dürer leaves for Italy, recording his progress through the Alps in watercolour studies.

Spring 1495

Returns to Nuremburg and begins to work as a painter and printmaker.

1498

Publishes his series of woodcuts illustrating the Apocalypse.

1502

Dürer's father dies.

1503

Hans Baldung Grien and Hans Suess von Kulmbach join Hans Schauffelein in Dürer's workshop.

1505

Travels to Venice where he paints the altarpiece of the *Feast of the Rosegarlands*, dated 1506 (now National Gallery, Prague), for the church of the German merchants in Venice, S. Bartolomeo. Also visits Bologna and possibly Rome.

1507

Returns to Nuremberg. Undertakes the Heller Altarpiece (completed in 1509, now lost).

1511

Paints the Landauer Altarpiece of All Saints (Kunsthistorisches Museum, Vienna).

1512

Becomes artistic advisor to Emperor Maximilian I and executes numerous commissions for him, including contributions to the woodcut *Triumphal Arch*.

1519

Emperor Maximilian I dies.

1520

Embarks on a journey to the Low Countries partly to secure patronage from Maximilian's successor, Charles V. Documents the trip in his own travel diary, which also records his business transactions.

1521

Meets the scholar and humanist Erasmus of Rotterdam. Draws, and eventually engraves, his portrait.

1526

By now a supporter of Martin Luther, gives four paintings of the Apostles to the Nuremberg Town Council.

6 April 1528

Dies at Nuremberg, possibly from malaria. His estate totalled the substantial sum of 6,874 florins. His wife Agnes inherited his property and lived in their house until her death in 1539.

This book was published to accompany an exhibition at
the National Gallery, London
24 March – 20 June 2004

First published in Great Britain in 2004 by
National Gallery Company Limited
St Vincent House, 30 Orange Street
London WC2H 7HH
www.nationalgallery.co.uk

ISBN 1 85709 365 8 525471

British Library Cataloguing-in-Publication Data
A catalogue record is available from the British Library

PUBLISHER Kate Bell
PROJECT EDITOR Tom Windross
DESIGNER Heather Bowen
PICTURE RESEACHER Kim Klehmet
PRODUCTION Jane Hyne and Penny Le Tissier

Origination by D.L. Repro Ltd.
Printed and bound in Hong Kong by Printing Express Ltd.

FRONT COVER: *The Great Piece of Turf*, 1503 (detail of fig. 9)
BACK COVER: *The Virgin and Child ('The Madonna with the Iris')*, about 1500–10 (fig. 22)

All works are by Albrecht Dürer (1471–1528) unless otherwise specified.
Measurements give height before width.